LAYOUT AND DESIGN FOR CALLIGRAPHERS

ALAN FURBER

TAPLINGER PUBLISHING COMPANY, NEW YORK

Published in 1984 by
Taplinger Publishing Co., Inc.
New York, New York

Copyright 1984 by Alan Furber
All Rights Reserved
Printed in the United States of America

LIBRARY OF CONGRESS CATALOGING IN PUBLICATION DATA

Furber, Alan.
 Layout and design for calligraphers.

 1. Calligraphy. I. Title.
Z43. F96 1984 745.6'1 83-18160
ISBN 0-8008-4573-0 (pbk.)

contents

To *riti,*
who planted
the seed.

This book was written
to supplement the resource
material available to
todays calligrapher. Many
books have been written
on the making of beautiful
letter forms (e.g. Pearce,
Svaren, et al),
but none deal
exclusively
with arranging
those letters into
visually harmonious
relationships. The emphasis
in this book is on layout,
not letters, with material
drawn from hundreds of
class hours spent teaching
layout and design
to calligraphers.

preface

introduction The basic design principles which follow can be applied successfully to most problems of calligraphic composition. Before beginning any layout, however, it is useful to identify and list each element which will appear in the finished piece. For example,

1. HEADING
2. SUB-HEADING
3. TEXT
4. AUTHOR
5. DECORATION
6. DATE
7. CALLIGRAPHER

By deciding which item is the most important, which is secondary and so on, you can avoid inadvertently allowing an unimportant element to dominate your work, or even omitting an item.

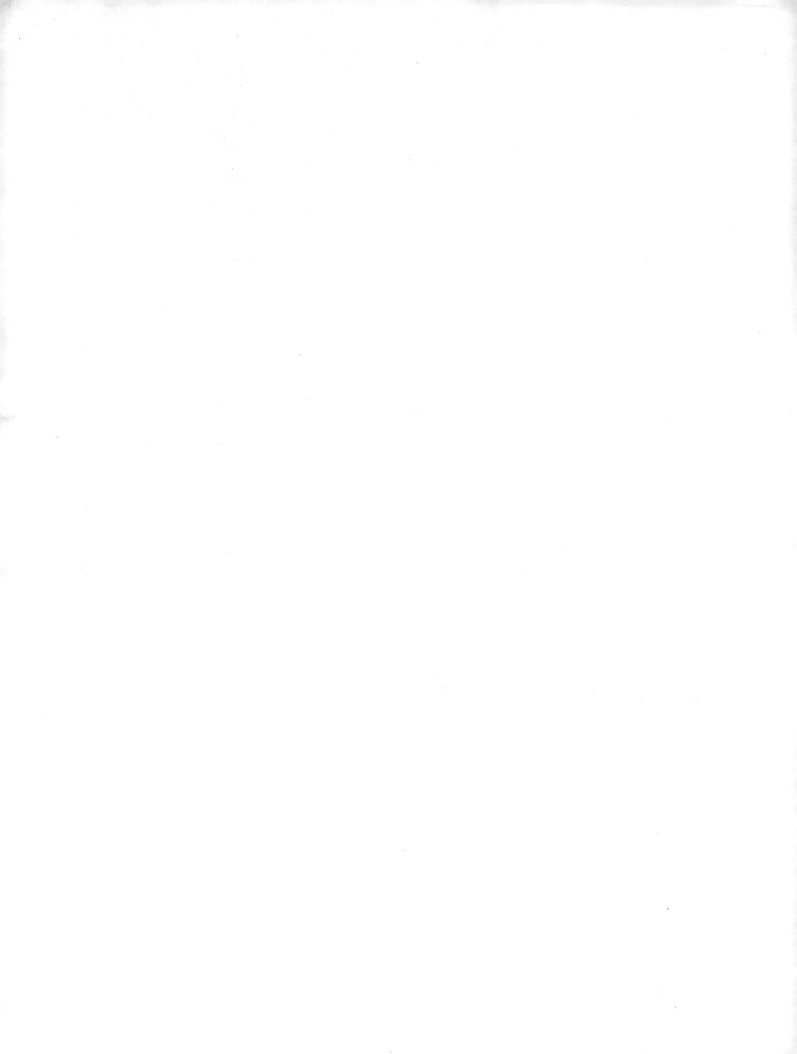

The most important
element in any
well-designed
layout is balance.

Webster
defines balance as
"A stability produced by
an even distribution of weight
on each side of a
vertical axis."
In a calligraphic layout,
balance also refers to an
even distribution of
weight above and below
an optically-centered
horizontal axis
which lies slightly above
the true center.

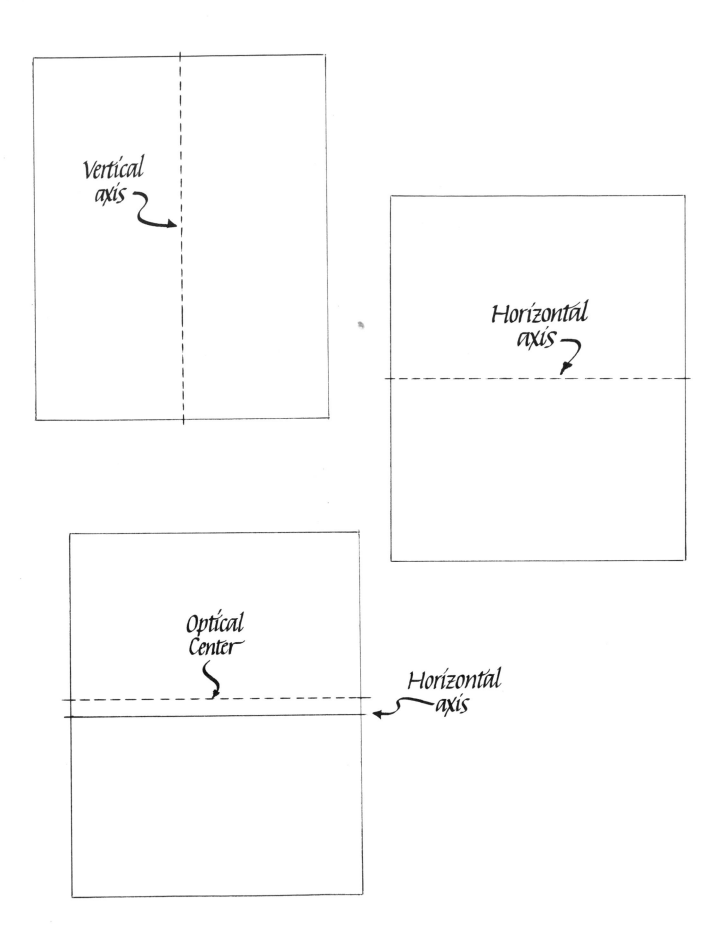

Vertical axis

Horizontal axis

Optical Center

Horizontal axis

Centered on horizontal axis
(too low)

On optical center – balanced

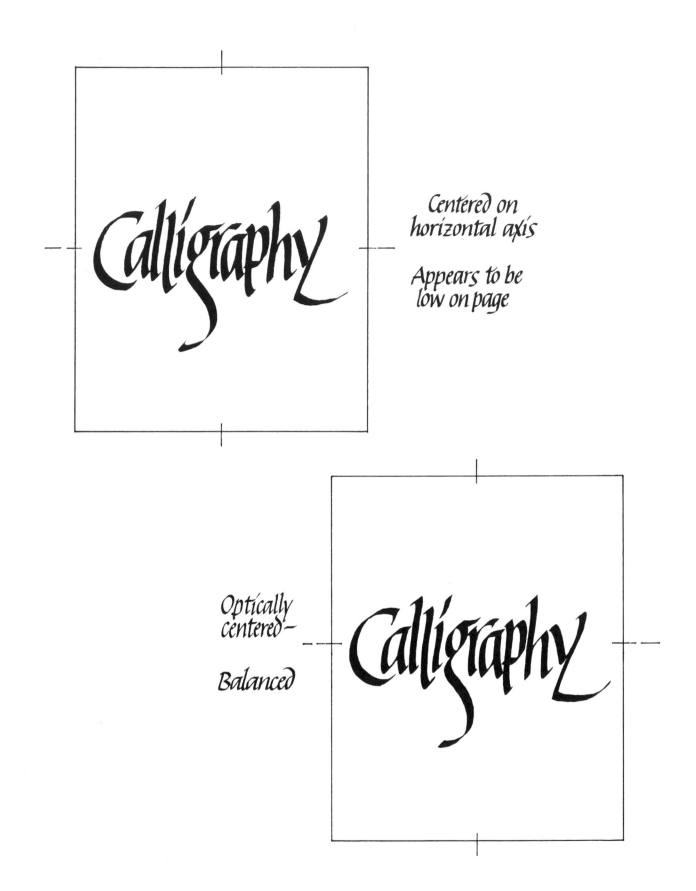

Centered on
horizontal axis

Appears to be
low on page

Optically
centered –

Balanced

When designing a
calligraphic work,
keep in mind
the shape of your finished
product. Whether rectangular,
circular or free-form, your
design should lie comfortably
within the margins.

A wider margin at the bottom
of your work will support
the art visually and keep it
from appearing to drop off
the page.

Text appears to be low on page

Margin proportions

Acceptable

Author's preference

Any balanced
calligraphic
composition
can be made
more interesting if
there is

contrast

between the design
elements. This
"diversity of
adjacent parts" can
be achieved in a
variety of ways:

- CONTRAST IN SIZE
- CONTRAST IN WEIGHT
- CONTRAST IN POSITION
- CONTRAST IN STYLE
- CONTRAST IN COLOR

SIZE

WEIGHT

POSITION

STYLE

contrast

SIZE &
WEIGHT

COLOR

16

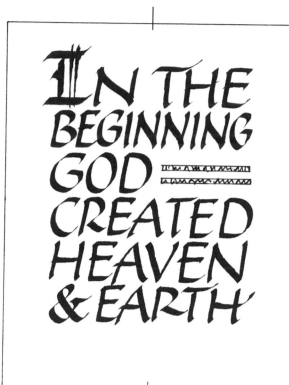

IN THE BEGINNING GOD CREATED HEAVEN & EARTH

ONCE UPON A TIME

Examples of Contrast

WHEREAS,
WHEREAS,
WHEREAS,
RESOLVED,

STOPPING BY THE STORE ON A RAINY EVENING

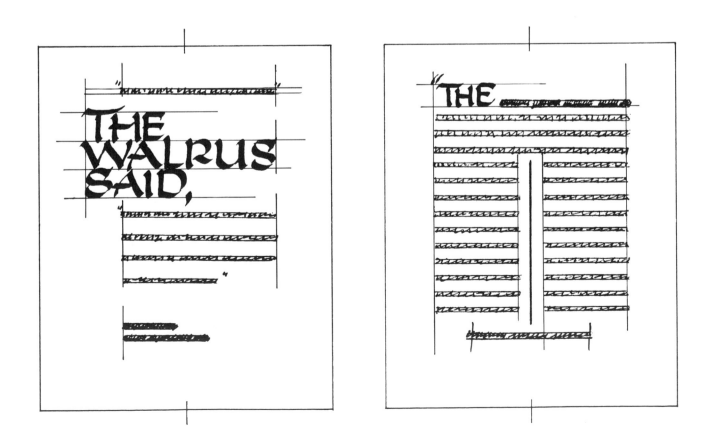

"THE TIME HAS COME"
the Walrus said,
"TO SPEAK OF MANY
THINGS, OF SHOES
AND SHIPS AND
SEALING WAX, OF
CABBAGES AND
KINGS."

LEWIS CARROLL

Examples of timid contrast

Improved contrast

Dominance

In any design
consisting of more than
a single element,
additional
interest is
added
when one element
dominates the others.
This dominance gives the
eye a starting point in
viewing the design
and customarily is used
to draw attention to
the most important
word or phrase. A
design may be
dominated by a letter,
a word, a phrase,
an entire paragraph,
an illustration
or a bit of color.

LAYOUT DESIGN

[body text lines]

CALLIGRAPHY

Which is the heading?

LAYOUT DESIGN

[body text lines]

CALLIGRAPHY

Improved

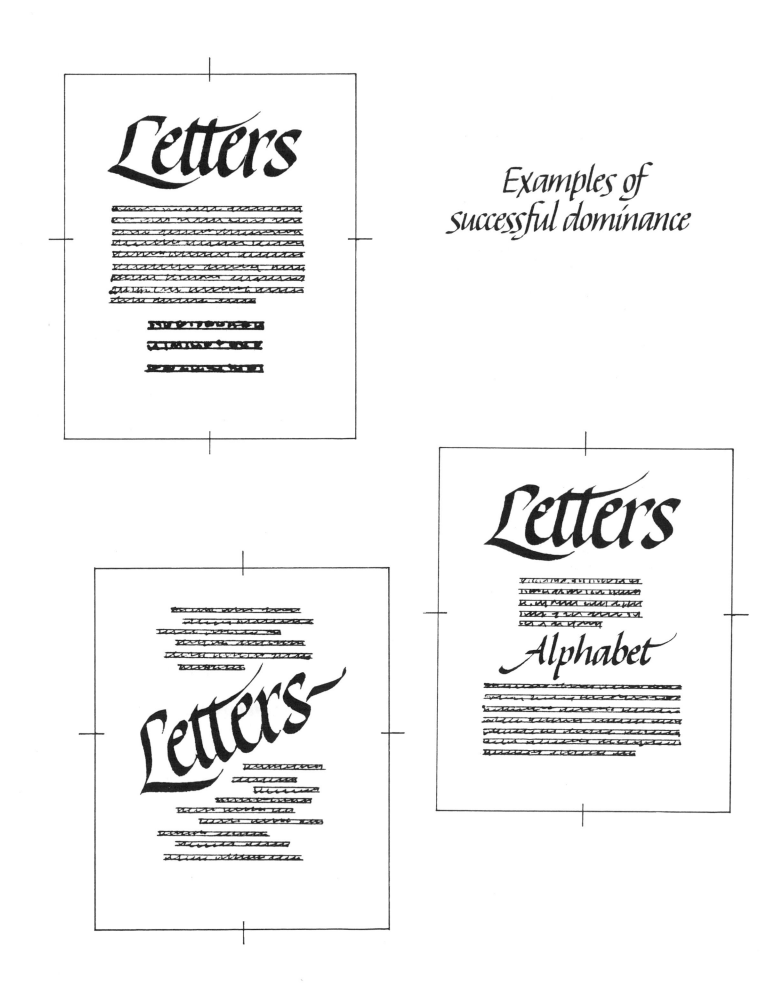

Examples of
successful dominance

CALLIGRAPHY

CALLIGRAPHY

TEXTURA

PRECISSUS

CALLIGRAPHY

UNCIAL

CAROLINGIAN

HUMANIST

CALLIGRAPHY

TEXTURA

CHANCERY

ROTUNDA

UNCIAL

CAROLINGIAN

HUMANIST

Examples of successful dominance

An element
can also dominate
when it is

isolated

by white space.

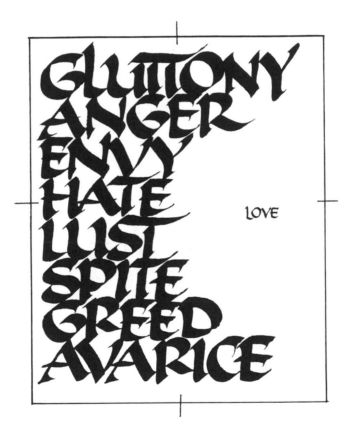

GLUTTONY
ANGER
ENVY
HATE
LUST LOVE
SPITE
GREED
AVARICE

however, when 2, 3 or more elements in your composition are equally dominant, there is no center of interest and the design is weakened as a consequence.

Too much dominance

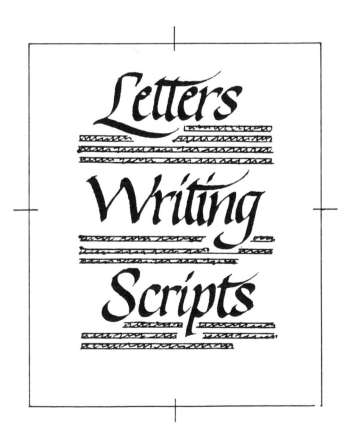

headings

Because the heading
customarily is the first
element of a design to be
noticed, its placement
is an important
consideration in a layout.

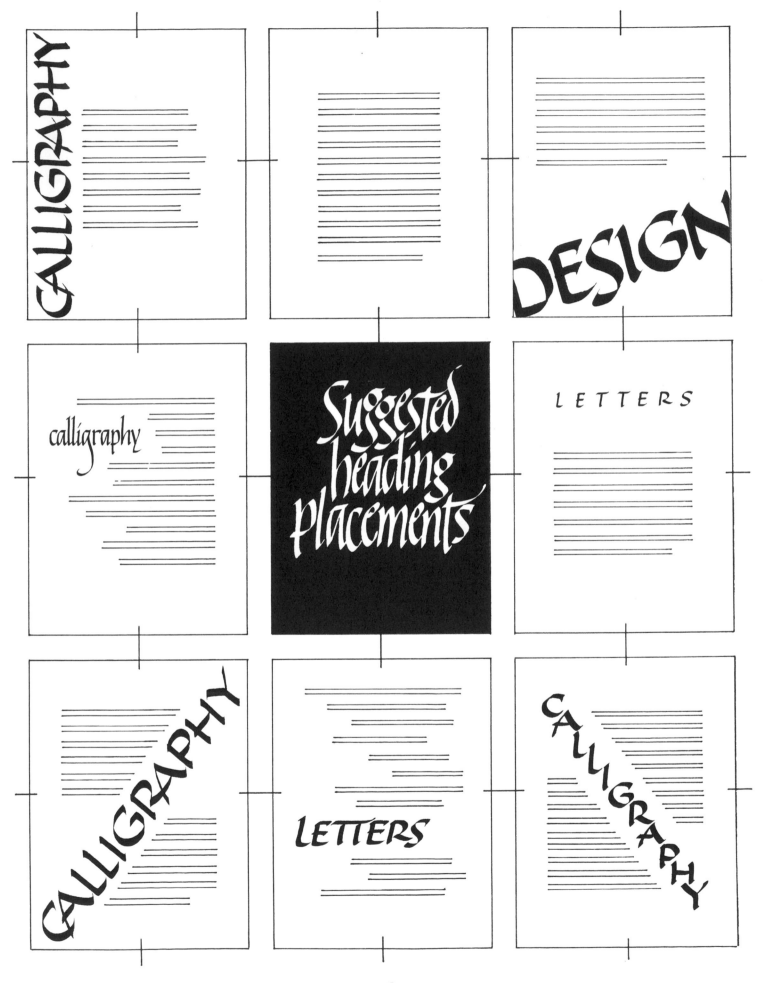

Lettering

*Too low
on page*

CALLIGRAPHY

*Text relettered
to allow more
space at bottom
of page*

Lettering

CALLIGRAPHY

Methods of improving a layout

Lettering

CALLIGRAPHY

Layout is top heavy

Lettering

CALLIGRAPHY

Text repositioned

Lettering

CALLIGRAPHY

Sub-title strengthened

How the calligrapher
 spaces the lines
 in a composition
 depends upon
 the letterstyle
linespacing used. Blackletter
 densely fitted
 together lends
 itself to a closer
 linespacing than italic,
 for example, which
 may require a wider
 linespacing to ensure
 readability.

Monotonous line spacing

Spacing adds interest

Flush left, ragged right
spacing

Flush right, ragged left
spacing

CERTIFICATE
OF MERIT

Sally Smith

CALLIGRAPHY I

Acceptable line spacing

CERTIFICATE
OF MERIT

Sally Smith

CALLIGRAPHY I

Improved

CERTIFICATE
OF MERIT

Sally Smith

CALLIGRAPHY

Off-balance on right

CERTIFICATE OF MERIT

Sally Smith

CALLIGRAPHY

Improved

An effective
method of
establishing
a design
is through
the use of

"thumbnails."

These proportionate small, very loose sketches
are used in trying out various solutions to
layout problems. They are a form of graphic
shorthand. An acceptable "thumbnail" is
redrawn at full size, still in rough form. This
rough sketch is then refined in one or more
semi-finished layouts from which the final
piece is developed.

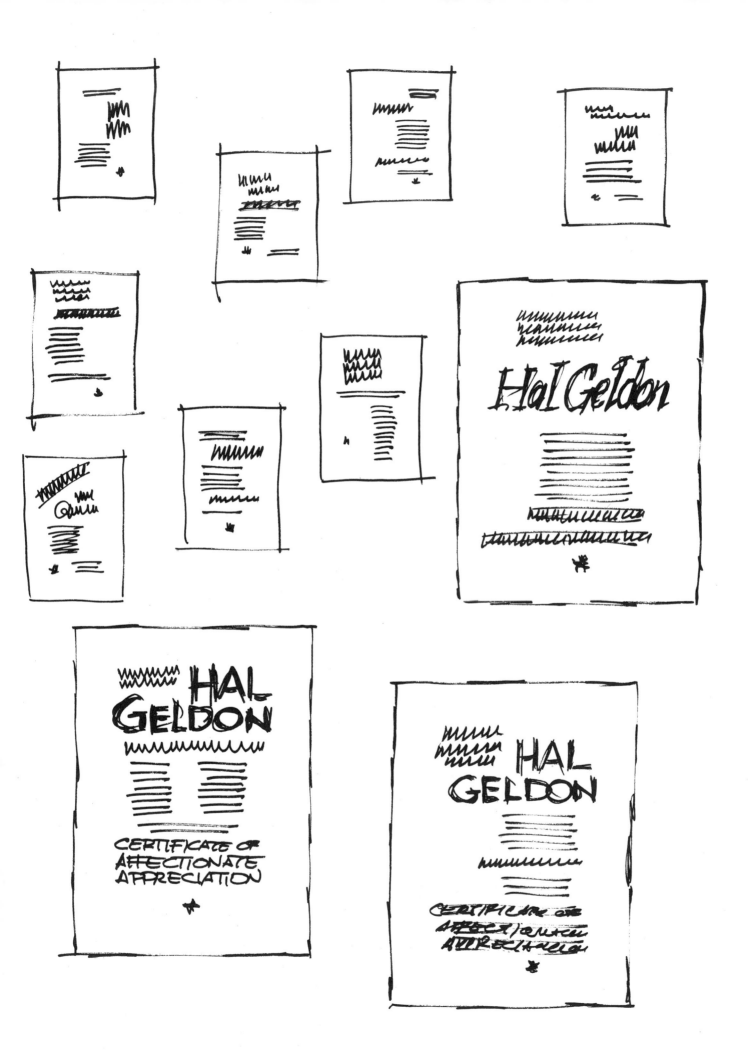

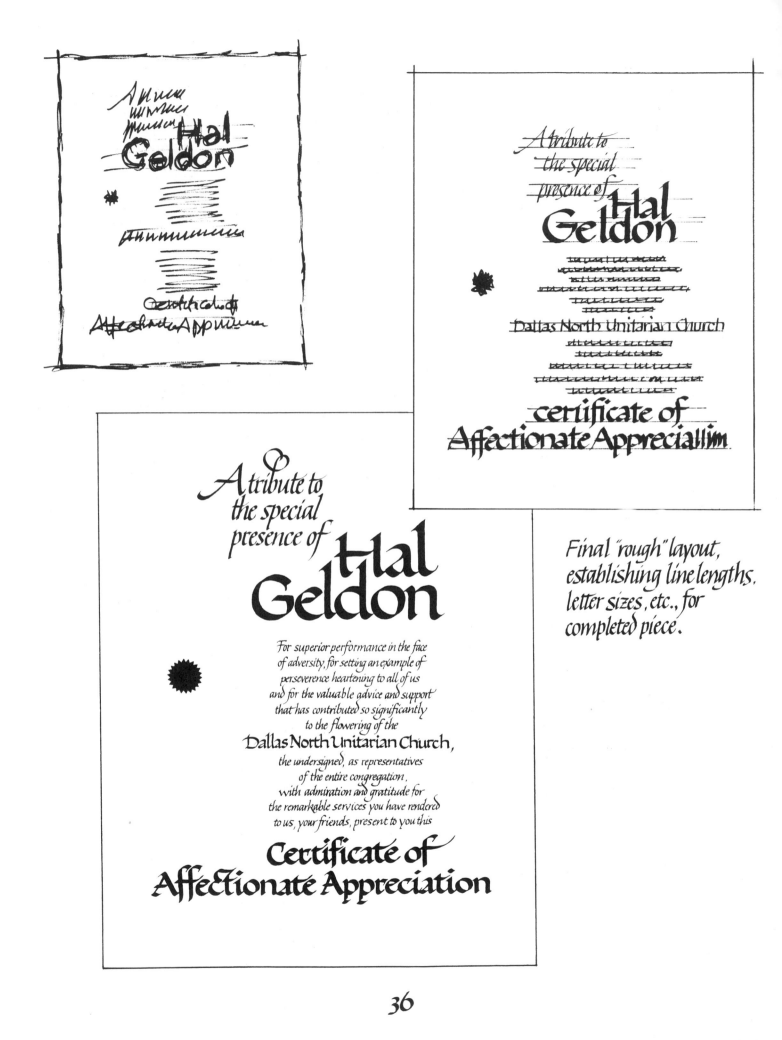

A tribute to
the special
presence of **Hal Geldon**

For superior performance in the face
of adversity, for setting an example of
perseverance heartening to all of us
and for the valuable advice and support
that has contributed so significantly
to the flowering of the
Dallas North Unitarian Church,
the undersigned, as representatives
of the entire congregation,
with admiration and gratitude for
the remarkable services you have rendered
to us, your friends, present to you this

**Certificate of
Affectionate Appreciation**

Final "rough" layout,
establishing line lengths,
letter sizes, etc., for
completed piece.

36

Formal Layouts

In the symmetrical world of
the formal layout
the left half of the design
is a reflection of the right half.

HEADING

Uninteresting layout

HEADING

Improved

Some formal layout problems & solutions

Improved

All elements not centered

HEADING

HEADING

HEADING

Too-even spacing

HEADING

Improved

Some formal layout problems & solutions

Too-open spacing

HEADING

Improved

HEADING

EASTFIELD COLLEGE COMMUNITY SERVICES

Certificate of Merit

This certificate is hereby awarded to

Diane Hammill

in acknowlegement of having
successfully met the requirements
for completing

Calligraphy I

_____ _____
DATE INSTRUCTOR

European-trained,
and with 24 years of hair-dressing experience,

Baki

is an internationally-known hair designer.
His expert hair-coloring and highlighting
will complement your skin tones
and reflect your personality.
For a free consultation, call Baki at

HAIR
CHATEAU
361-2886

We invite you to make an appointment.

(IMMEDIATE OPENING FOR EXPERIENCED HAIR DESIGNER)

Examples of good formal layouts

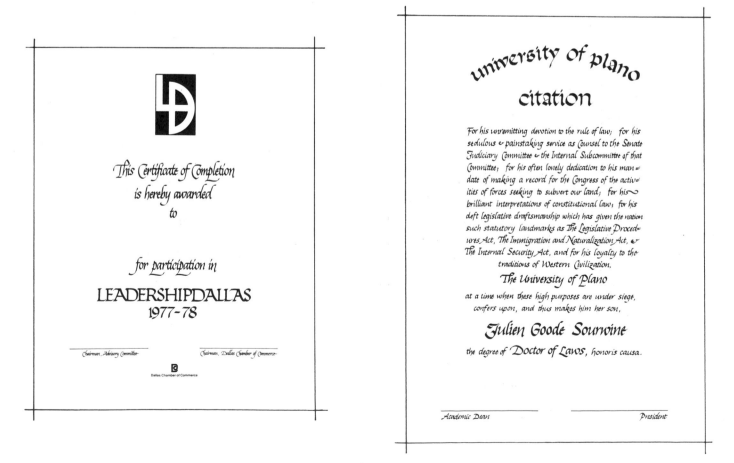

This Certificate of Completion
is hereby awarded
to

for participation in

LEADERSHIPDALLAS
1977-78

_____ _____
Chairman, Advisory Committee Chairman, Dallas Chamber of Commerce

Dallas Chamber of Commerce

university of plano
citation

For his unremitting devotion to the rule of law; for his
sedulous & painstaking service as Counsel to the Senate
Judiciary Committee & the Internal Subcommittee of that
Committee; for his often lonely dedication to his man-
date of making a record for the Congress of the activ-
ities of forces seeking to subvert our land; for his
brilliant interpretations of constitutional law; for his
deft legislative draftsmanship which has given the nation
such statutory landmarks as The Legislative Proced-
ures Act, The Immigration and Naturalization Act, &
The Internal Security Act, and for his loyalty to the
traditions of Western Civilization.

The University of Plano
at a time when these high purposes are under siege,
confers upon, and thus makes him her son,

Julien Goode Sourwine

the degree of Doctor of Laws, honoris causa.

_____ _____
Academic Dean President

40

WHEREAS

Franklyn,

son of the Duke of Gentile,
hath performed in exemplary style
for lo, these six weeks past, therefore
be it known that he is to be considered,
by all to whom these presents may come,
to be a true
SOUTHERN GENTLEMAN,
HONORARY TEXAN
&
MINISTER EXTRAORDINAIRE

Signed this day, FEBRUARY 27, 1977, at Fellowship Hall, Plano, Texas, …by

President, Unitarian Universalist Fellowship North.

SUNNY 25 SOUTH

On our 25th Anniversary
~ OCTOBER 1976 ~
Sunny South Fashions
wishes to extend
the warmest appreciation
to our customers.

We look forward
to many more years of
fashion excellence,
friendship and mutual success

Examples of good formal layouts

It is better to light one candle
than
to curse
the darkness

Gala for Dodie

CHAMPAGNE KIR COCKTAIL
Elaine

SHRIMP PÂTÉ
Delys

ASPARAGUS SOUP
Jim

ORIENTAL FILLET
Betty

FRENCH MUSTARD MAYONNAISE
Betty *Barbara*

Wine: San Martine Burgundy

SPINACH TIMBALES
Betty & Kay

VEGETABLE PÂTE
Madge & Sheryl

FRESH FRUIT WINE MOLD
Elaine

BEETROOT & ENDIVE SALAD
Jane

FROMAGES PAIN ORDINAIRE
Alice *Linda & Barbara*

Wine: San Martine Chablis

STRAWBERRY CHARLOTTE MALAKOFF
Connie, Jed, Rachel & Susan

ESPRESSO CHOCOLATS
Linda *Sheryl*

Ice sculpture & garnishes
by Judy

Calligraphy by Ann

BUFFET MENU

APRIL 24, 1982

The **informal**
layout
is any
balanced
composition
without
the
mirror-image
quality of the
formal
layout.

HEADING

Layout too zig-zag (⚡)

HEADING

Improved

Some informal layout problems & solutions

Off-balance on left

HEADING

Improved

HEADING

HEADING

Runs downhill to right (↘)

HEADING

Improved

Some informal layout problems & solutions

Too much space between elements

HEADING

Improved

H EADING

I believe in the dignity & worth of the individual human being.

I am dedicated to increasing the individual's understanding of himself and of how he or she relates to others. The means I use shall be for the benefit of my clients according to my ability and judgement, and not for any wrong purpose. I will conduct all of my dealings, regardless of their nature, with honesty, fairness and dignity. I will hold as sacred secrets those things I see or hear in the performance of my duties, or even apart therefrom, that ought not to be discussed elsewhere. I will serve both individuals and organizations according to the character and needs of each, and recognizing that my ultimate responsibility is to the individual. I reserve for myself the freedom to follow my professional interests and to communicate the results of my work. I accept the responsibility this freedom confers: for right action, for competence where I claim it, for objectivity in the report of my work and for consideration of the best interests of my clients, my profession and of society. I will not use, nor allow others to use, the cloak of the profession for purposes inconsistent with this oath. While striving toward these ends, I will protect the privacy and welfare of any person seeking my service.

The Kwik Kopy Printing Center Owners of Dallas join KRLD in saluting **Harvey Martin** for your professional excellence. We extend to you our **special thanks** for bringing your positive influence and winning attitude to our community.

Examples of good informal layouts

American Heart Association

PUBLIC SERVICE AWARD

PRESENTED TO **NATIONAL ADVERTISING COMPANY**

For donating the shopping center advantage to the American Heart Association

DALLAS, TEXAS
NOVEMBER 14, 1982

Order Of Perfection

There are no mistakes without progress.

TO FORGIVE IS HUMAN; TO ERR, DIVINE.

The President and the members of the Board of Directors of Kaligrafos, Ltd. hereby award this certificate in rueful acknowledgement of the fact that nobody's perfect, including

President, Kaligrafos, Ltd. Date

We
commemorate
this day, May 22, 1983
in grateful recognition of
MARY PORTER
for the dedication, courage and
commitment shown as a
founding member of the
DALLAS NORTH UNITARIAN CHURCH
in February of 1975
and for continued support
in advancing the ideals
and principles of
Unitarian Universalism
in our community.

[signature] MINISTER

[signature] MEMBERSHIP CHAIRMAN

Florence and Harold Winer
invite you to attend An
Engagement
Party
honoring our daughter
MARGARITE
and her fiance
JAMES MILLER KAPLAN
of New York City

Sunday, August 8, 1982
5-8 p.m.
7329 Lakehurst,
Dallas, Texas 75230

PLEASE REPLY.

Examples of good informal layouts

By planting
flowers,
you
invite butterflies;
by planting
pines,
you invite
the wind;
by planting
bananas,
you
invite the rain,
and, by planting
willow trees,
you invite
cicadas.

CHAO
CH'ING

to
Chip

Oh, the comfort — the inexpressible
comfort of feeling safe with a person.
Having neither to weigh thoughts,
nor measure words, but pouring them
all right out — just as they are —
chaff and grain together —
certain that a faithful hand will
take them and sift them —
keep what is worth keeping
and with the breath of kindness,
blow the rest away.

Dallas is a truly wholesome place to bring up families and a friendly,
fast-paced place to do business. It is a city with a momentum
all its own, where the American dream of owning your home
and developing your own opportunities can be achieved. Dallas
means vigorous private enterprise, professional and positive
local government, good educational opportunities and
a strong special community.

Welcome to the offices of
the Watson & Taylor Companies,
a firm that is proud to be based in Dallas.

the contributions of business and commerce, individual roles
of business people, and the businesslike
approach that Dallas takes toward
government, growth, and quality
of life are important developments
in the development of this
special city. These have been
carefully cultivated and encouraged.

in Dallas for over 100 years, there is a "mystique", a special "can-do"
attitude which is distinguished by a willingness to be part of
the greater good and to share one's blessings.

We at the Watson & Taylor Companies believe in the positive
attitudes of the region and its citizens at this time in history.
We feel fortunate to be able to participate in
the development of this city.

46

initials

The use of initials as design elements in calligraphic work has a long and rich tradition. Today initials can be used to achieve the same effect as they did centuries ago in the early manuscripts or they can serve as decorative touches in our contemporary layouts.

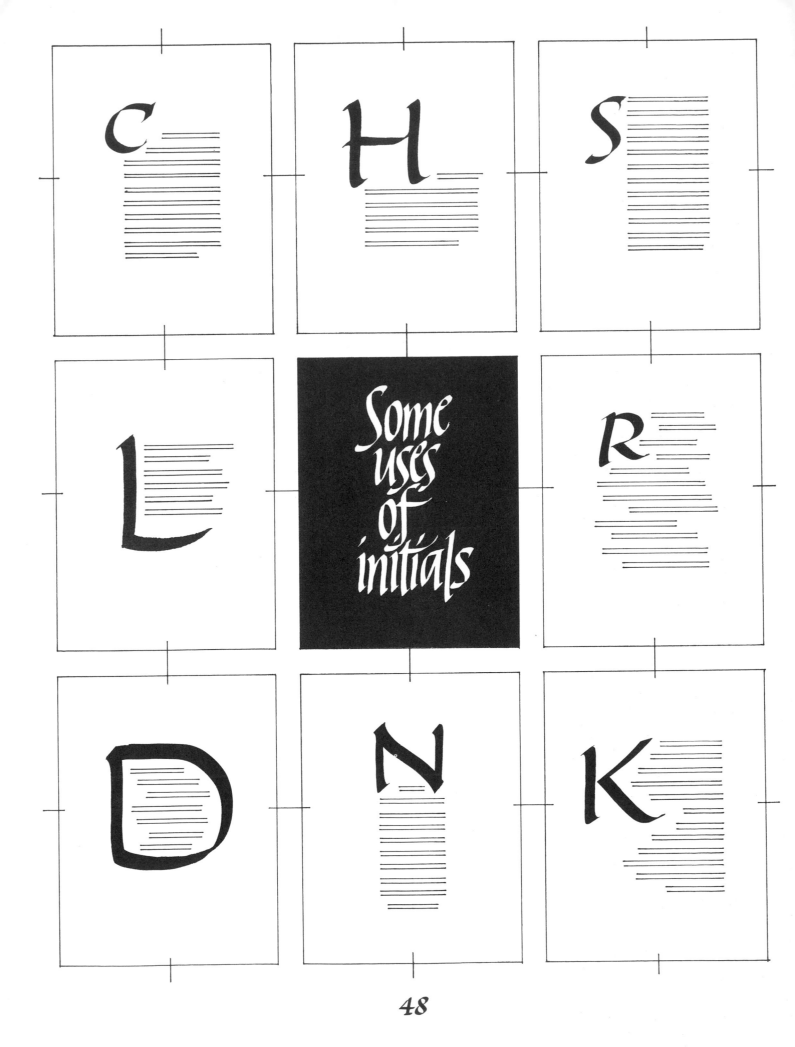

Some uses of initials

Text contorted
to fit layout

Initial is irrelevant to text

Initial is pointless
design element

Initials
overwhelm text

borders

A well-designed border surrounding your calligraphy can add a finished look to your design. In general, a symmetrical border looks best around a formal layout.

If your completed work is to be framed, consider the type of frame when designing the border, to avoid a style conflict or redundancy.

A colored mat which is complementary to your calligraphy can also be used as an effective border.

Simple effective borders

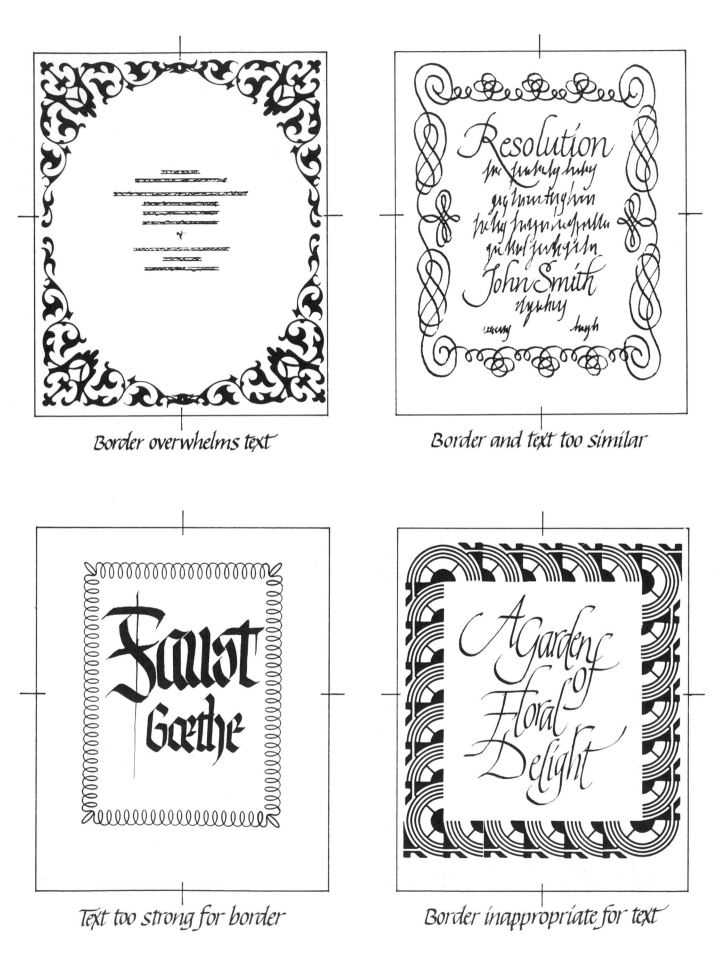

Border overwhelms text

Border and text too similar

Text too strong for border

Border inappropriate for text

52

LARGE QUANTITIES
OF MASSED COPY
EQUAL VISUAL
CHLOROFORM.

text masses

To add interest, separate your
copy into shorter paragraphs of
contrasting appearance, and
emphasize a selected section.

DO NOT USE MORE THAN 3,
AND PREFERABLY ONLY 2,
LETTER STYLES ON A SINGLE
PIECE OF CALLIGRAPHY, TO
AVOID A CLUTTERED LOOK.

With some care and advance
planning, your completed art
will be a pleasure to read.

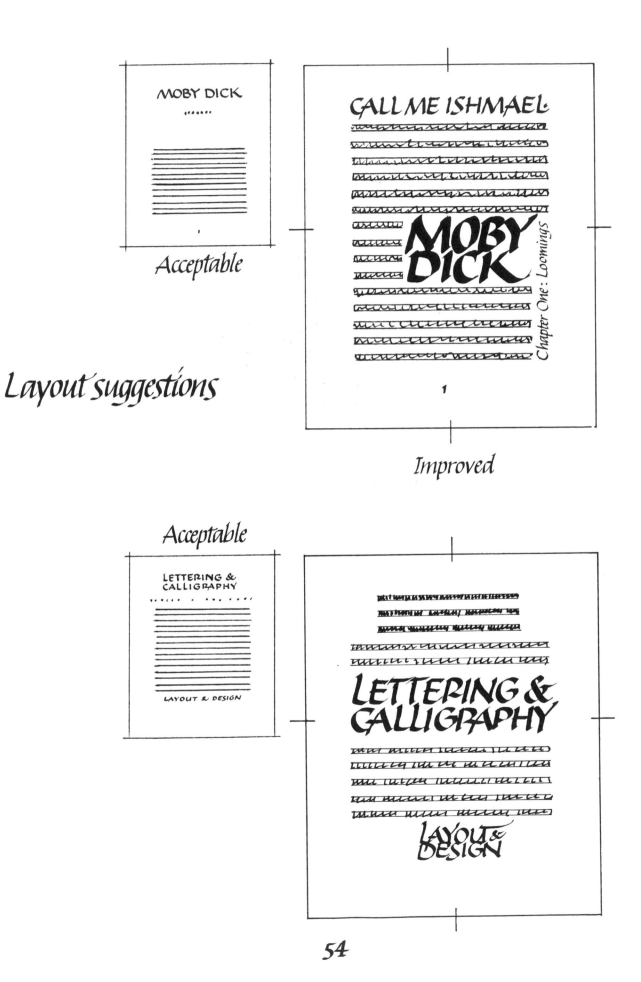

MOBY DICK

Acceptable

Layout suggestions

CALL ME ISHMAEL·

MOBY DICK

Chapter One: Loomings

1

Improved

Acceptable

LETTERING &
CALLIGRAPHY

LAYOUT & DESIGN

LETTERING &
CALLIGRAPHY

LAYOUT &
DESIGN

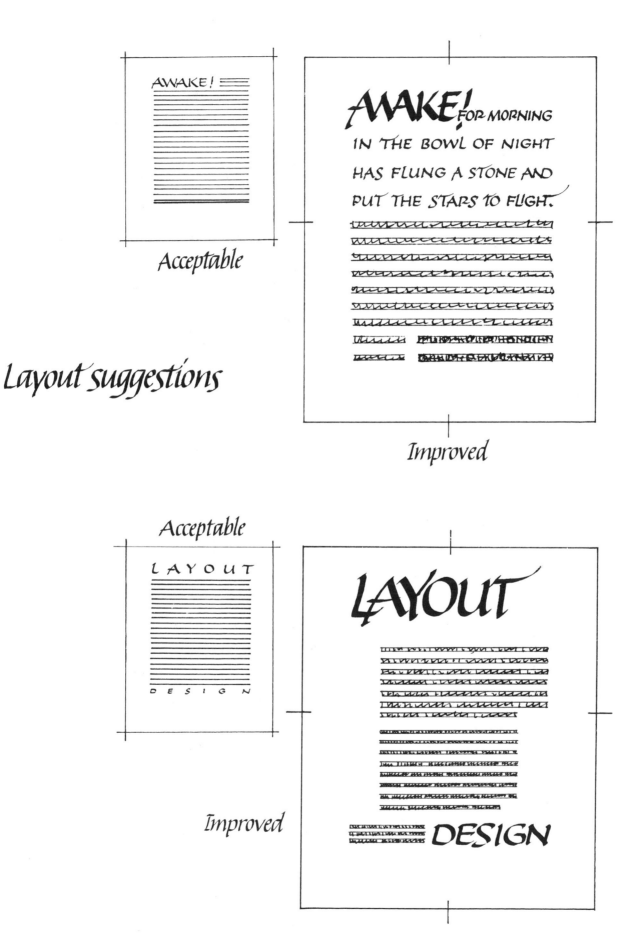

AWAKE! FOR MORNING
IN THE BOWL OF NIGHT
HAS FLUNG A STONE AND
PUT THE STARS TO FLIGHT.

Acceptable

Improved

Layout suggestions

LAYOUT

DESIGN

Acceptable

Improved

55

ONE, TWO, THREE,

Acceptable

ONE,
TWO,
THREE,
FOUR,
FIVE,
SIX,
SEVEN,
EIGHT,
NINE,
TEN,
ELEVEN,
TWELVE,
AND SO ON.

Improved

Layout suggestions

Acceptable

F

FOURSCORE AND SEVEN YEARS AGO,

ABRAHAM
LINCOLN | GETTYSBURG
ADDRESS · 1865

Improved

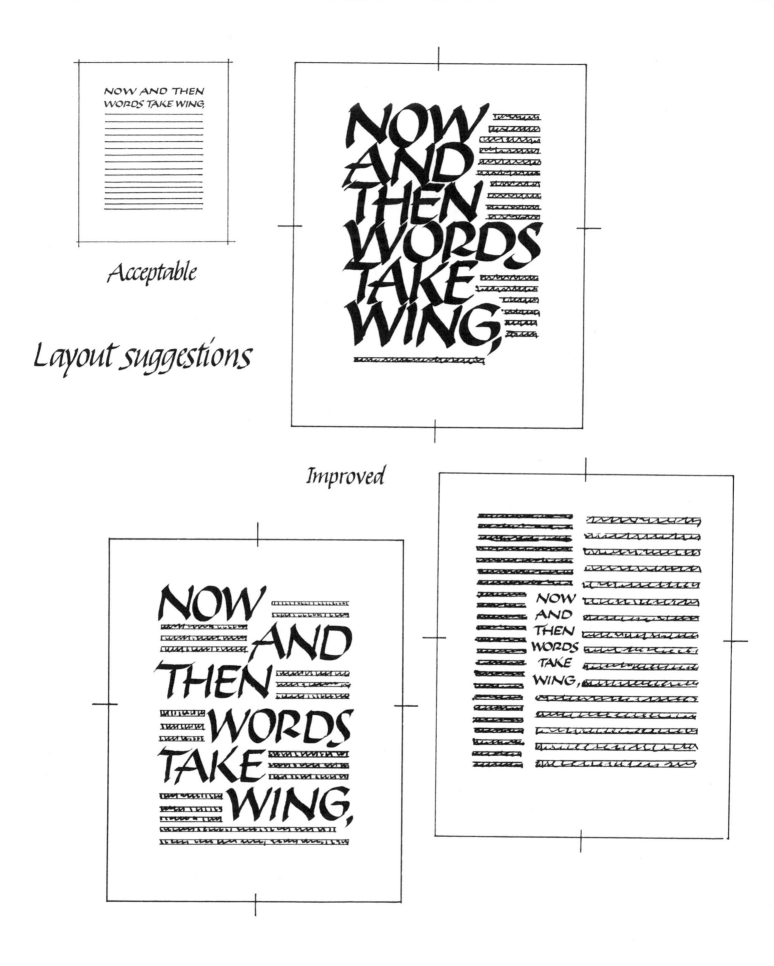

NOW AND THEN
WORDS TAKE WING,

Acceptable

Layout suggestions

Improved

Because we usually can learn more by
doing, rather than by just reading, you
may enjoy working on the four

which follow, incorporating the
information in this book into
your design layouts.

The text for each exercise has been
left undifferentiated, allowing you
the design choice of
which element(s) to emphasize.

Questions

to consider while

working on your layouts.

1. Are all of the elements listed in order of importance?

2. Did you loosen up with several rough, sketchy thumbnails?

3. Are the margins open, rather than cramped?

4. Is your design visually balanced?

5. Is there contrast between elements?

6. Is only one element dominant?

Exercise 1 Design a formal

invitation.

Size: 5" wide by 8" high

Item: Invitation to a formal dinner party

Text: Dr. and Mrs. A.B. Seady request the pleasure of your
company for cocktails and dinner at seven p.m. on
the sixth of January, 1985 to help them celebrate their
fiftieth wedding anniversary. 876 South Road,
Deerfield. Dress: formal. RSVP – 555-4321

Reminder: let your design reflect
the elegance of this affair.

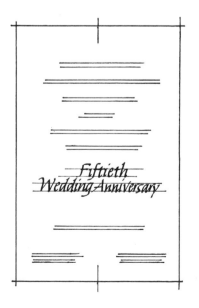

One possible layout solution

Exercise 2 Design a formal

award.

Size: 8" wide by 10" high

Item: Company Service Award

Text: North/South Institute Certificate of Appreciation
awarded to Lincoln Morse in recognition of a
lifetime of devoted service to this organization
September 28, 1984 (Signed) Edward Bixby,
Vice President and Trustee

Reminder: include a small
gold seal with ribbon somewhere
in your layout.

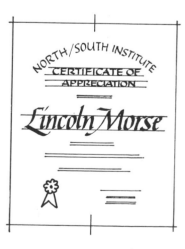

One possible layout solution

Exercise 3 Design an informal

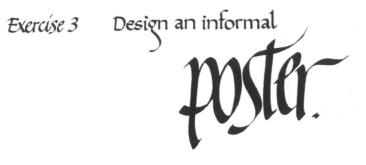

poster.

Size: 30" wide by 40" high

Item: Poster to be displayed in hotel lobby

Text: Lily Valley Coutouriers present a Fashion Show
Mondays and Wednesdays from 12 to 2 p.m. in
the Fountain Room on the Mezzanine

Reminder: this poster must be clear
and easily read from a distance.
Avoid clutter.

One possible layout solution

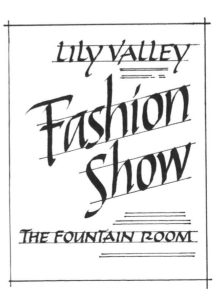

LILY VALLEY
Fashion
Show
THE FOUNTAIN ROOM

Exercise 4 Design an informal 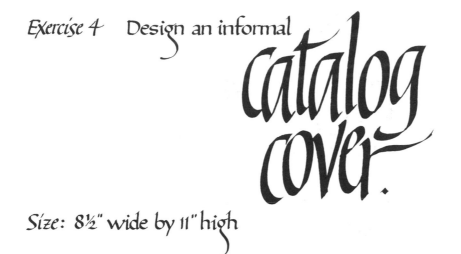catalog cover.

Size: 8½" wide by 11" high

Item: Cover for calligraphy store catalog

Text: The Pen Bin. A store supplying all of your calligraphy needs. 0123 Fourth St., Springfield, Arizona · (800) 555-6789

Reminder: make the reader want to open the catalog by arousing his interest with your design.

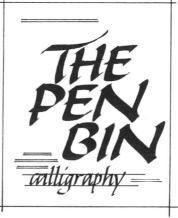

One possible layout solution

Summary

As the title indicates,
this book is only
an introduction to the
subject, and is intended
to help calligraphers
improve the appearance
of their work. No
book can take the place
of formal study, and
the more we practice
and learn, the better
designers we scribes
will become. I wish all
of you great success!